Adventures in Art

Assessment Masters

In English and Spanish

Laura H. Chapman

Eldon Katter

About Spanish Usage

Because of differences between North American and Hispanic language and culture, there may be minor discrepancies between the information provided in English and that provided in Spanish on some of the Assessment Masters.

For example, Spanish directions may ask children to underline rather than to circle the correct answer. Words that indicate color may differ: In most Latin American countries, lemons are green, not yellow, so the Spanish word for "banana" may be substituted for "lemon". Similarly, Latin American limes are yellow, not green, so the Spanish word for "lettuce" may have been substituted for "lime".

Please bear these possible differences in mind as you work with these Assessment Masters.

© 1998
Davis Publications, Inc.
Worcester, Massachusetts USA

Printed in the United States of America
ISBN: 0-87192-338-6
1 2 3 4 5 6 7 8 9 10 JCO 01 00 99 98 97

Front cover: Student artwork by James Brinkley, Bryant Elementary School, Mableton, Georgia. From the Crayola® Dream-Makers® Collection, courtesy of Binney & Smith Inc.

Bilingual consultants:
Tonie Garza, Director of Bilingual, ESL, Second Languages, Irving Independent School District, Irving, Texas
Dr. Romeo Romero, Coordinator of Bilingual, ESL, State Compensatory Programs, Laredo Independent School District, Laredo, Texas

Table of Contents

Please note: Masters 1–24 have been translated into Spanish.
The Spanish translations appear in the second half of this book.

Introduction

This set of 24 assessment masters can be reproduced on a copier, as needed, for classroom use. The set represents each of the four major content areas in the *Adventures in Art* program—perception, creative expression, culture and heritage, and informed judgment.

The reading matter on the assessment sheets is based on a "Living Word" list and can be understood by students when spoken or described by a teacher. The illustrations and line drawings on the sheets will also aid understanding.

Focus on Assessment

Most of the reproducible pages in this set focus on assessment. Assessment is an integral part of the teaching-learning process in art. It is carefully aligned with the stated learning objectives for the four major content areas. Based on the belief that all students can succeed, teachers should provide for adequate development of the concepts, ample practice testing, review, and re-testing before moving on to the next level.

Multiple Approaches

Diversified assessment involves the use of multiple assessment activities to gather information about students' progress and to measure more than just factual recall. Some assessment tasks focus on individual accomplishments and final products. Others examine the process of learning, not just the final result. Some assessments examine ways to solve specific problems or look for evidence of application of prior knowledge. Important and subtle forms of assessment can occur before, during, and after engaging students in learning activities.

Gathering Information

Valid assessment requires collecting adequate evidence of learning and maintaining complete records of student progress. Portfolios, sketchbooks, journals, self-evaluation checklists, interviews, written assignments, oral reports, worksheets, and performance activities are all important sources of information for assessment.

Reporting Progress

Many school districts now require a written record of student progress during the year as a way of keeping parents informed about their child's performance. In most situations, checklists supported by written comments on each child's progress are recommended instead of assigning a traditional letter grade for communicating with parents.

The last master sheet in each grade level set—**Number 24: Report to Parents**—is a checklist that can be reproduced and sent home with each child at various times throughout the school year. The criteria for each grade level is based on the concepts and skills specified in the **Scope and Sequence Chart** in the *Teacher's Edition.*

Using Assessment Masters

Most of these reproducibles have been designed as informal assessment activities for certain *Adventures In Art* lessons. Not every lesson will have a corresponding assessment master. The use of an assessment master for a specific lesson is highlighted in the text of the teacher's edition. Each master is referred to by a number and a title.

Exactly how each master is to be used is left to the discretion of the teacher. In some instances they may be used for pre-assessment or introductory activities at the beginning of an *Adventures* unit or lesson. Others might be more appropriate at the end of a lesson or unit. Some may be used twice, as both a pre-test and a post-test, to measure improvement in learning.

While most of these reproducible sheets are assessment tools, a few can serve as enrichment activities or lesson extensions. They are not, however, intended as stand-alone lessons.

The Role of the Teacher

The reading abilities of students vary tremendously within a grade level. In most instances, when using an assessment master, you should read the directions aloud, review or describe the words, explain the illustrations, and check for understanding of the task before the students proceed. When there are multiple

tasks on one sheet, you might consider guiding students through each task, one step at a time.

After students have completed the master, you should talk to them about the results or have them discuss their responses with their peers in small groups. Encourage your students to be supportive in helping others to understand their mistakes and to improve their performance.

Communicating

The completed assessment sheets can be placed in the students' portfolios along with studio work and written reports for parent conferences. In some situations, you might want to send them home, with your own brief note on the back. The affirmation statements at the bottom of each sheet can serve as prompts for children to engage in conversations with parents about what they have learned in art: "See Mom, I know about many kinds of art....This is a portrait, and this one's a landscape...."

Organization of Material

The concepts represented on the masters have been organized around the four major content areas—perception, creative expression, culture and heritage, and informed judgment—identified in the **Scope and Sequence Chart** on pages 2-3 of the *Teacher's Edition.*

The columns in the chart below indicate the number of each assessment master that corresponds to the concepts and skills to be acquired by all students at each level within each major content area of the *Adventures in Art* program.

Correlation to Major Content Areas in Art

LEVEL	Perception	Creative Expression	Culture & Heritage	Informed Judgment
1	1, 2, 3, 4, 5	6, 7, 8, 9, 10, 11	12, 13, 14, 15	16, 17, 18, 19, 20 21, 22, 23
2	1, 2, 3, 4, 5, 6	7, 8, 9, 10, 11, 12	13, 14, 15, 16	17, 18, 19, 20, 21 22, 23
3	1, 2, 3, 4	5, 6, 7, 8, 9, 10 11, 12, 13	14, 15, 16, 17, 18	19, 20, 21, 22, 23
4	1, 2, 3, 4, 5, 6	7, 8, 9, 10, 11, 12	13, 14, 15, 16, 17	18, 19, 20, 21, 22 23
5	1, 2, 3, 4, 5, 6	7, 8, 9, 10, 11, 12 13,	14, 15, 16, 17, 18	19, 20, 21, 22, 23
6	1, 2, 3, 4	5, 6, 7, 8, 9	10, 11, 12, 13, 14 15, 16, 17	18, 19, 20, 21, 22 23

Name _____ Date _____

Line Up

1. In art, a line is a path made by a moving point. Use your pencil like a moving dot to connect the dots with a wiggly line.

● ●

2. A line can become a shape. Draw the outline of each shape.

circle square triangle rectangle

3. Study these five main directions for line.
Can you also find lines that are long, short, thin, and wide?

vertical horizontal diagonal curved zigzag

4. Make a sketch of what is described under each box.
Draw lines that "tell" what the words mean.

trees that soar
upward

a calm, quiet lake

a happy,
dancing cat

a wild storm

I know about and can use a variety of lines.

Name _____ Date _____

Kinds of Lines

Artists use different kinds of lines to show how things look, feel, and move.
Draw lines that show the meaning of each word.

dashed	jagged	smooth
thick	thin	wavy
zigzag	swirling	snaking
vertical	horizontal	diagonal

On another sheet of paper, draw an imaginary place. Use all these kinds of lines.

I can draw a variety of lines.

Name _____ Date _____

Textures

Artists show textures in their works. In each box, draw a close-up view that shows textures. You do not need to draw the whole animal or object.

old weathered wood	fur of a kitten	porcupine spines
rough tree bark	wet, shaggy dog fur	thick grass
shell of a turtle	your own hair	broom bristles

I can create a variety of visual textures.

Name _____ Date _____

Patterns

Where do you see patterns? Look around. Do you see stripes? Plaids? Checkerboards? Polka dots? In each box, draw a pattern that you see.

Why do people like patterns? Where do you see patterns in nature? Why do artists create patterns?

I can see and create different patterns.

Name _____ Date _____

Word Play with Colors

Read these names of paint colors. How are these color words alike?

creamy white milk white	toast brown coffee brown	tangerine orange pumpkin orange	pea green avocado green
oyster gray pepper gray	lobster red strawberry red	lemon yellow yolk yellow	blueberry blue water blue

Choose six of these colors. What do they make you think about?
Create a colorful drawing of what you imagined.

Think of other names for colors. Try to come up with names for a box of animal colors.

I can express ideas with color.

Name _____ Date _____

Communicating Without Words

Visual elements—such as lines, shapes, and colors—can communicate a feeling or mood.
Write one word under each design.
You might want to tally and graph the results for the whole class.

| calm | fearful | lonely | confused | worried |
| tired | tense | angry | cheerful | |

1. _____

2. _____

3. _____

4. _____

5. _____

6. _____

7. _____

8. _____

9. _____

I can see expressive qualities in art.

Name _____　Date _____

Drawing an Imaginary Place

Artists use different kinds of lines to show ideas and feelings.
Draw a picture of an imaginary place. Is the place beautiful, strange, or scary?
Make a drawing with different kinds of lines.

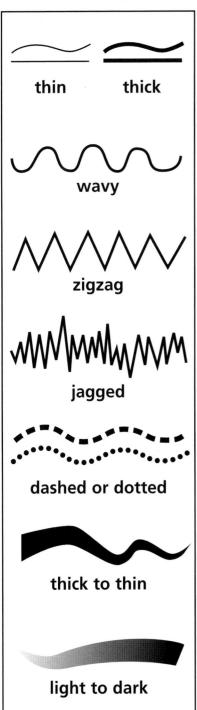

thin　　thick

wavy

zigzag

jagged

dashed or dotted

thick to thin

light to dark

I can use lines to show ideas and feelings.

Name _____ Date _____

Action Figures

1. You need nine paper fasteners.
 Cut out the shapes and put them together.
2. Create action poses like the ones shown.
3. Sketch two poses but do not trace the pattern.
 Add details to make an action-packed drawing.

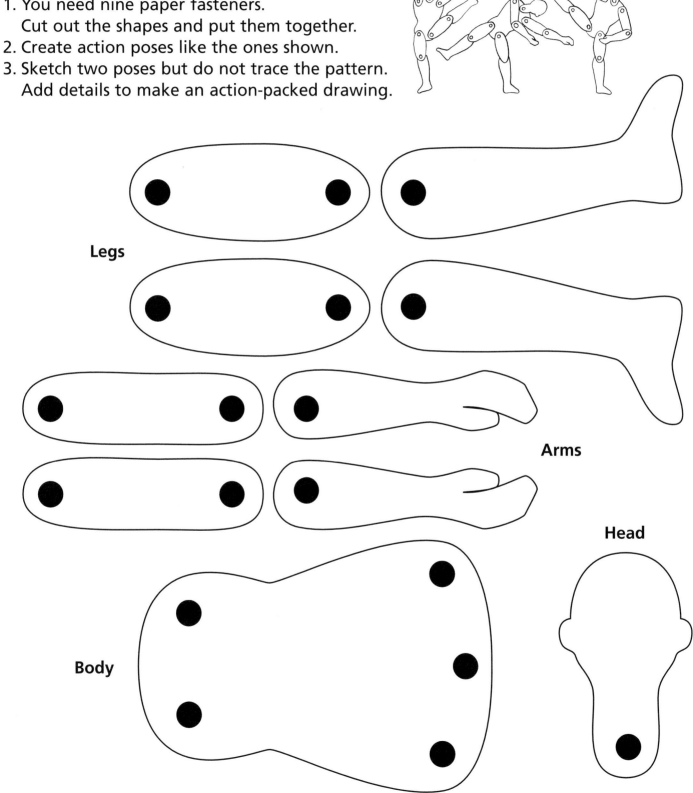

Legs

Arms

Head

Body

I can draw action figures.

Name _____ Date _____

Fascinating Details

Details in an artwork are small shapes, patterns, textures, and shifts in color.
Imagine that there are colorful insects and butterflies on and near this plant.
Fill the space with these creatures and other details.

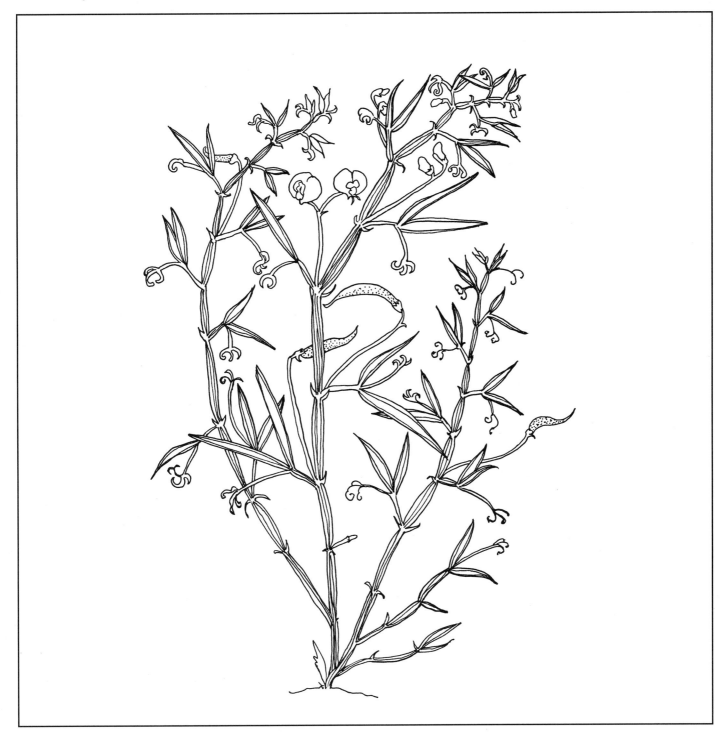

I can draw details.

Name _____ Date _____

Expressive Trees

In each box, sketch a tree with its own expressive qualities.
Use your pencil in different ways to show what each name means.
If you don't know exactly how each tree really looks, use your imagination.

1. a mighty oak 2. a lonesome pine 3. a dancing palm

4. a weeping willow 5. a sugar maple 6. a stately elm

Which is your best sketch? Why?

I can create expressive drawings.

Name _____ Date _____

A Radial Design

1. Do you like puzzles? Use a ruler and a sharp pencil to draw a line between dots 1 and 1, 2 and 2, and so on. Connect the seven pairs of dots on the outside of the octagon.

2. Now draw lines to connect the pairs of dots on the inside of the octagon (8 and 8, 9 and 9, and so on). You will draw a total of 16 straight lines.

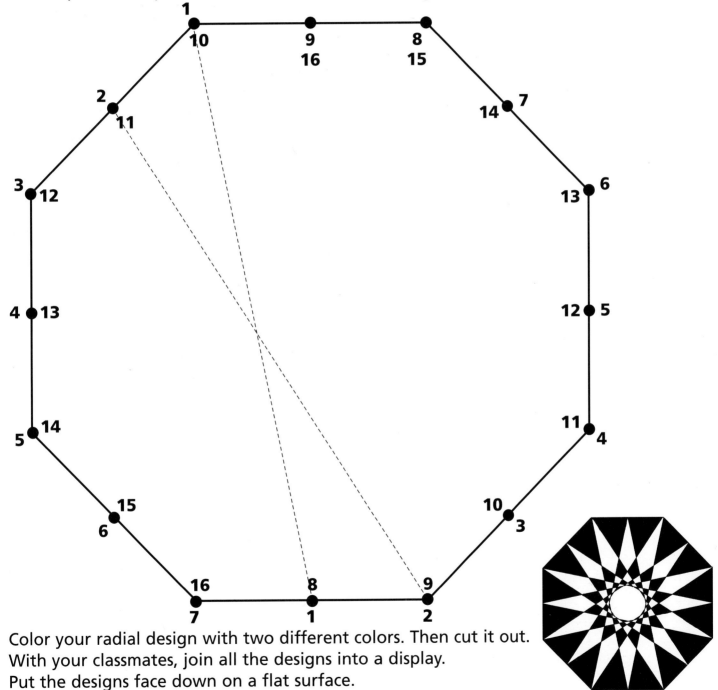

Color your radial design with two different colors. Then cut it out.
With your classmates, join all the designs into a display.
Put the designs face down on a flat surface.
Match the edges and tape the designs together.

I can create a radial design.

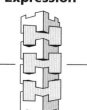

Name _____ Date _____

A Modular Sculpture

Artists sometimes make sculptures with modules—similar or like forms that fit together.

1. Cut out each strip, and then cut out the notches.
2. Fold each strip on the dotted lines, and paste the tabs on the inside, as shown at the right.
3. Stack the modules in different ways to make your modular sculpture.

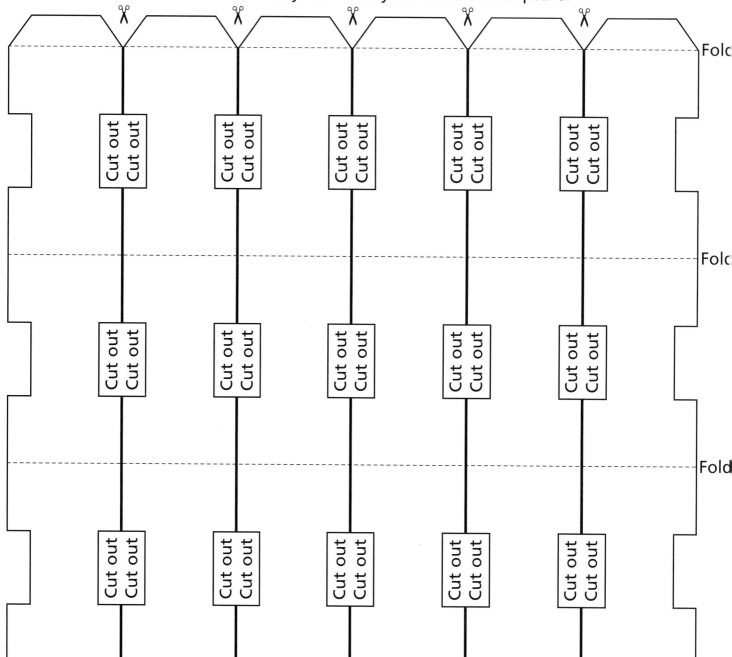

What other modules can you make to create a sculpture?

I can create a modular sculpture.

Name _____ Date _____

History Comes Alive

Write the names of two artists who lived in different times. (Michelangelo and Picasso, for example). What would they say is special about their art? Write a conversation between them. Draw the scene of where they are talking.

A Conversation Between _____ **and** _____

Name _____ Date _____

Restore an Old Crazy Quilt

Here's a corner fragment of a crazy quilt. Use your imagination to restore it.
What kinds of lines, shapes, designs, patterns, and details might the quilt have had?
Color your design with crayons, markers, or colored pencils to make your quilt as bright
as when it was new.

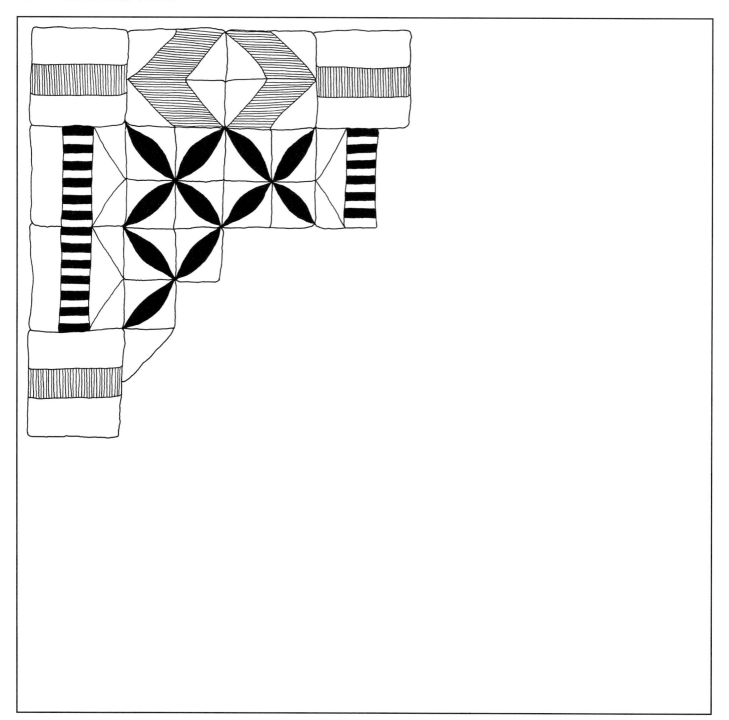

I understand ideas about restoration.

Name _____ Date _____

Styles of Chairs

Cut out each card. Then cut across the dotted lines. You will have 12 parts of chairs. Mix and match the top and bottom parts of the chairs. Which chairs look odd when the parts don't match? Why are most chairs designed so that the top and bottom parts have the same style?

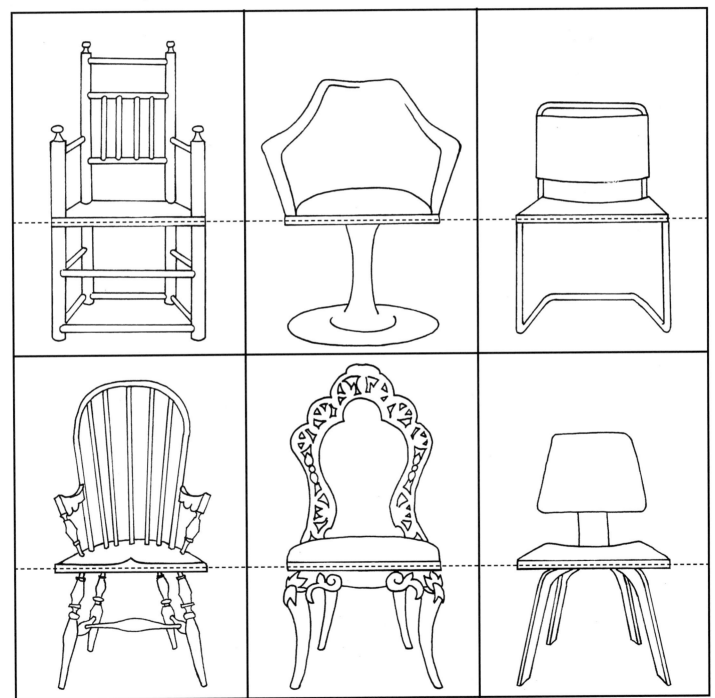

I know about different styles.

Name _____ Date _____

Art You Like

Put an X in the box next to the kind of art you like best. Ask some of your friends or family members to put an X next to the kind of art they like best.

	Landscapes
	Seascapes
	Portraits
	Still Lifes
	Nonobjective Artworks

Count the Xs in each box.

How many people like landscapes? _____

How many people like seascapes?_____

How many people like portraits? _____

How many people like still lifes?_____

How many people like nonobjective artworks?_____

More people like _____ than_____

Fewer people like _____ than_____

Why do you think people like some kinds of art more than other kinds?

I know that people prefer some kinds of art more than other kinds.

Name _____ Date _____

A Day Without Art

Artists design many things you see and use. Imagine starting off a day without art!
The cereal box has no design.
The cereal bowl has no color or pattern.
The spoon needs a shape.
You can change all of that now!
Add design, color, and shape
to start your day with art.

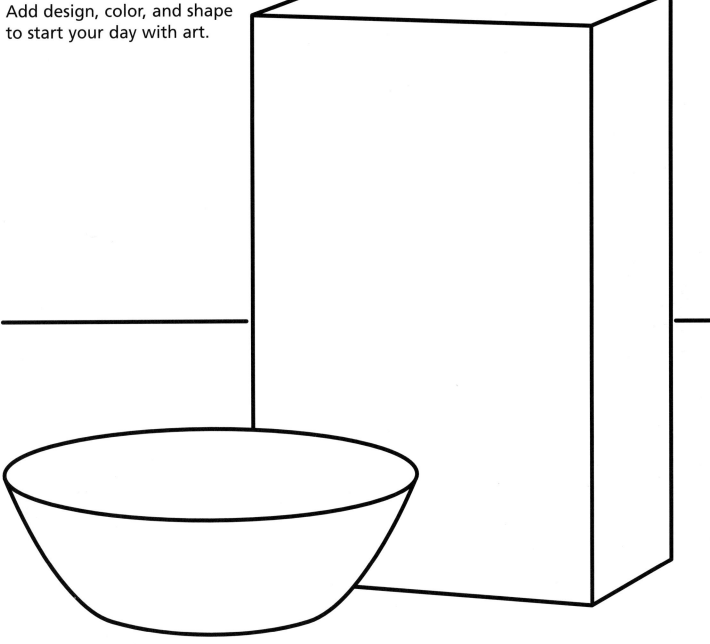

I know about art in daily life.

Name _____ Date _____

Analyzing an Artwork

Your teacher will show you an artwork. Look at it carefully. Check the box in each row that best describes what you see. For example, if the artwork has many bright colors, check the box at the far left. If it has both bright and dull colors, check the middle box. In the empty rows, add other things you notice.

many bright colors	☐ ☐ ☐ ☐ ☐	many dull colors
many dark colors	☐ ☐ ☐ ☐ ☐	many light colors
many cool colors	☐ ☐ ☐ ☐ ☐	many warm colors
smooth textures	☐ ☐ ☐ ☐ ☐	rough textures
shapes with clear outlines	☐ ☐ ☐ ☐ ☐	shapes with fuzzy edges
realistic shapes	☐ ☐ ☐ ☐ ☐	flat or invented shapes
space looks deep with distant views	☐ ☐ ☐ ☐ ☐	space looks flat or close up
areas with many details	☐ ☐ ☐ ☐ ☐	areas with few details
areas with symmetrical balance	☐ ☐ ☐ ☐ ☐	areas with asymmetrical balance
	☐ ☐ ☐ ☐ ☐	
	☐ ☐ ☐ ☐ ☐	
	☐ ☐ ☐ ☐ ☐	

Discuss results with classmates. Talk about the reasons for any differences.

I know how to analyze art.

Name _____ Date _____

Reporting on Art

Imagine that you work for a newspaper. You are to write about an artwork of your choice. Complete the outline with notes about the artwork.

Artist's name _____

Title of artwork _____

Where the work can be seen _____

Materials used to make the artwork _____

How the artist used the materials _____

What the artwork shows _____

Special things to notice _____

Why people might want to see the artwork _____

Other ideas: _____

Use your notes to write a story that tells people about the artwork.
Use another sheet of paper.

I can plan and write a report about art.

Name _____ Date _____

Autobiography

Choose an artwork from your book. Imagine that the artwork can speak. What story would it tell about its life? Complete the outline with notes about the artwork.

My name is (title of work) _____

How I was created _____

Places I have been _____

What people have admired about me _____

What I wish people would really notice about me now _____

Important events I have lived through_____

Other things I think about _____

Use your notes to write an imaginary autobiography of the artwork.
Use another sheet of paper.

I can plan and write about art.

Name _____ Date _____

Take a Walk

Your teacher will show you a landscape painting. A landscape is an outdoor scene. Pretend you could become very small and walk into this scene. Look around. Walk through the landscape. Write down what you see and how the artist shows it.

What I See	**How The Artist Shows This**
The weather is _____ _____.	_____ _____
The time of day is _____ _____.	_____ _____
The season is _____ _____.	_____ _____
The wind is_____ _____.	_____ _____
The coolest place is _____ _____.	_____ _____
The warmest place is_____ _____.	_____ _____
The most interesting thing is _____ _____.	_____ _____

I know ways to look at art.

Name _____ Date _____

You Can Be an Art Critic

An art critic writes and speaks about artworks. An art critic helps people think about art.

Cut out the four strips. Fold each strip in half to make an art-criticism card.
Use the cards to talk and write about art. Be an art critic!

1. Look	**2. Look Again**	**3. Think**	**4. Judge**
Look at the art-work carefully. What does the artist want you to see?	Look for the overall design in the artwork.	Think about what you see and feel. What does the artist want you to think about or feel?	Decide what you like or dislike about the art-work.
_____	_____		_____
_____	_____	_____	
_____	The overall design helps you see how the art-work is planned.	_____	Tell why you like or dislike the art-work.
_____		_____	
_____		_____	_____
		_____	_____

------ FOLD HERE ------ | ------ FOLD HERE ------ | ------ FOLD HERE ------ | ------ FOLD HERE ------

Things to See	**Plans to Notice**	**Examples**	**Questions**
• subjects • materials • lines • colors • shapes • textures • forms • spaces (Your teacher can help you understand these terms.)	• patterns • balance • motions • rhythms • emphasis • unity • variety (Your teacher can help you understand these terms.)	Feelings: • weirdness • joy • fear • sadness Ideas: • wisdom • beauty • courage • love	Why do you think the artist made this? What might other people think about this artwork? Why? What do you like and dislike about the artwork?

I know how to criticize art.

Name _____ Date _____

Proverbs About Art

Read each statement about art and think about it.
Next to each statement, write what you think it means.

There are pictures
in poems and
poems in pictures.

Art has no enemy
except ignorance.

There is an art
even in roasting apples.

Those who have
an art have
everywhere a part.

I can explain statements about art.

Report to Parents

_____ is making progress in these areas of art.
(student)

Creative Expression

_____ Uses design concepts for specific purposes, such as color to express a mood and repetition to create visual rhythms.

_____ Uses media to build skills and flexibility in creating expressive two- and three-dimensional art.

_____ Gives attention to expressive intentions.

Perception

_____ Identifies subtle visual qualities in the natural and constructed environments and in artworks.

_____ Sees moods, implied paths of movements, and interactions of colors and shapes.

Culture and Heritage

_____ Compares and contrasts the cultural and historical functions of artworks.

_____ Recognizes the traditions of art in daily life.

_____ Respects the creation and study of art as a life-long pursuit or career.

Informed Judgments

_____ Seeks answers to questions about the qualities of artworks.

_____ Makes informed and thoughtful judgments about artworks.

Other Comments:

Nombre _____ Fecha _____

Alíneate

1. En el arte, una línea es la trayectoria de un punto en movimiento. Usa tu lápiz como un punto en movimiento para conectar los puntos con una línea ondulada.

● ●

2. Una línea puede convertirse en una figura. Traza la forma de cada figura.

círculo cuadrado triángulo rectángulo

3. Estudia estas cinco orientaciones principales de las líneas.
¿Puedes hallar también líneas largas, cortas, finas y gruesas?

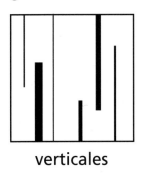

verticales horizontales diagonales curvas en zigzag

4. Dibuja lo que se describe bajo cada recuadro.
Traza líneas que "digan" lo que significan las palabras.

árboles que se elevan un lago tranquilo un gato alegre una tormenta
hacia el cielo que baila furiosa

Conozco y sé usar muchas líneas diferentes.

Nombre _____ Fecha _____

Tipos de líneas

Los artistas usan diferentes tipos de líneas para mostrar el aspecto, la textura y el movimiento de las cosas. Traza líneas que muestren el significado de cada palabra.

punteada	dentada	lisa
gruesa	fina	ondulada
en zigzag	en espiral	serpenteante
vertical	horizontal	diagonal

En una hoja aparte, dibuja un lugar imaginario. Usa todos estos tipos de líneas.

Sé dibujar muchos tipos de líneas.

Nombre _____ Fecha _____

Texturas

Los artistas muestran texturas en sus obras. En cada recuadro, dibuja un primer plano que muestre las texturas. No tienes que dibujar el animal ni el objeto entero.

madera deteriorada	el pelaje de un gatito	las espinas de un puercoespín
la corteza áspera de un árbol	el pelaje largo y mojado de un perro	hierba tupida
el caparazón de una tortuga	tu propio pelo	la paja de una escoba

Sé crear muchos tipos de texturas visuales.

Nombre _____ Fecha _____

Patrones

¿En dónde puedes ver patrones? Mira a tu alrededor. ¿Ves rayas? ¿Cuadros escoceses?
¿Tableros de ajedrez? ¿Lunares? En cada recuadro, dibuja uno de los patrones que ves.

¿Por qué le gustan los patrones a la gente? ¿Qué patrones puedes ver en la naturaleza?
¿Por qué los artistas crean patrones?

Sé reconocer y crear diferentes patrones.

Nombre _____ Fecha _____

Juegos de palabras con los colores

Lee los siguientes nombres de colores de pintura. ¿En qué se parecen estas palabras sobre los colores?

blanco cremoso blanco lechoso	marrón tostado café con leche	naranja mandarina naranja calabaza	verde limón verde aguacate
gris ostra gris pimienta	rojo manzana rojo fresa	amarillo banana amarillo yema	azul arándano azul agua

Escoge seis de los colores. ¿En qué te hacen pensar?
Haz un dibujo lleno de colorido de lo que imaginaste.

Piensa en otros nombres de colores. Trata de inventar nombres para una caja de colores de animales.

Puedo expresar ideas con colores.

Nombre _____ Fecha _____

Comunicarse sin palabras

Los elementos visuales —como las líneas, formas y colores— pueden comunicar una emoción o estado de ánimo. Escribe una palabra bajo cada diseño.
Quizás quieras contar y poner en una gráfica los resultados de toda la clase.

| tranquilo | temible | solitario | confundido | preocupado |
| cansado | tenso | enojado | alegre | |

1. _____

2. _____

3. _____

4. _____

5. _____

6. _____

7. _____

8. _____

9. _____

Sé reconocer cualidades expresivas en el arte.

Nombre _____ Fecha _____

Dibujar un lugar imaginario

Los artistas usan diferentes tipos de líneas para mostrar ideas y emociones.
Dibuja un lugar imaginario. ¿Es bello, extraño o temible?
Usa diferentes tipos de líneas en tu dibujo.

finas **gruesas**

ondulada

en zigzag

dentada

de puntos

de gruesa a fina

de clara a oscura

Puedo usar las líneas para mostrar ideas y emociones.

Nombre _____ Fecha _____

Figuras en acción

1. Consigue nueve sujetadores de metal para papel.
 Recorta las formas y arma la figura.
2. Forma poses en acción como las que se muestran.
3. Dibuja dos de las poses sin calcar el patrón.
 Añade detalles para crear un dibujo lleno de acción.

Piernas

Brazos

Cabeza

Cuerpo

Sé dibujar figuras en acción.

Nombre _____ Fecha _____

Detalles fascinantes

Los detalles en el arte son pequeñas formas, patrones, texturas y cambios de color.
Imagina que hay insectos y mariposas de muchos colores en o cerca de esta planta.
Llena el espacio con esos animales y con otros detalles.

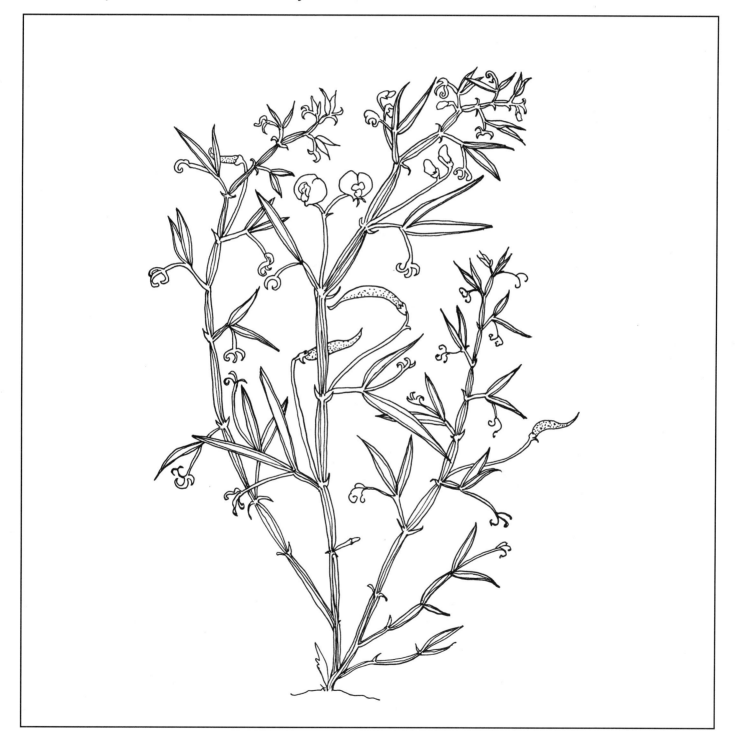

Sé dibujar detalles.

Nombre _____　　　Fecha _____

Árboles expresivos

En cada recuadro, dibuja un árbol que tenga sus propias cualidades expresivas.
Usa tu lápiz de diferentes maneras para mostrar lo que significa cada nombre.
Si no sabes exactamente cómo es cada árbol, usa tu imaginación.

1. un roble robusto	2. un pino solitario	3. una palmera bailarina
4. un sauce llorón	5. un arce azucarero	6. un olmo señorial

¿Cuál es tu mejor dibujo? ¿Por qué?

Sé crear dibujos expresivos.

Nombre _____ Fecha _____

Un diseño radial

1. ¿Te gustan los acertijos? Usa una regla y un lápiz con buena punta para trazar una línea entre los puntos 1 y 1, 2 y 2, y así sucesivamente. Conecta los siete pares de puntos que quedan fuera del octágono.

2. Luego traza líneas que conecten los pares de puntos que quedan dentro del octágono (8 y 8, 9 y 9, y así sucesivamente). Dibujarás un total de 16 líneas rectas.

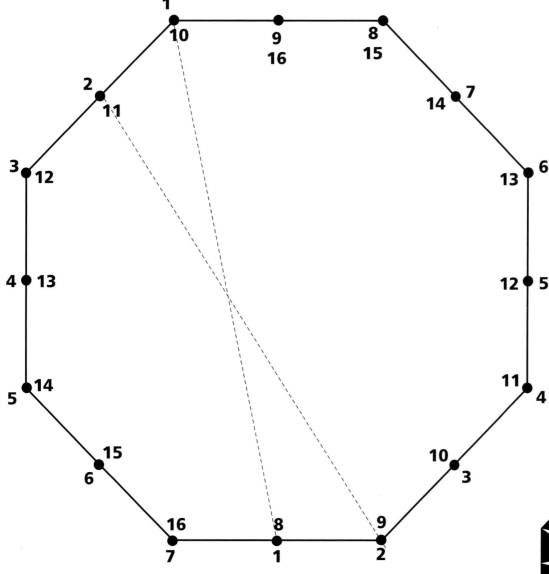

Colorea tu diseño radial con dos colores. Luego recórtalo.
Con tus compañeros, une todos los diseños en una presentación.
Coloquen los diseños boca abajo sobre una superficie plana.
Unan los bordes de los diseños con cinta adhesiva.

Sé crear un diseño radial.

Nombre _____ Fecha _____

Una escultura modular

A veces los artistas hacen esculturas con módulos —formas similares que encajan juntas.

1. Recorta cada tira, y luego recorta las muescas.
2. Dobla cada tira por las líneas de puntos y pega las lengüetas por la parte de adentro, como se muestra.
3. Apila los módulos de diferentes maneras para hacer tu escultura modular.

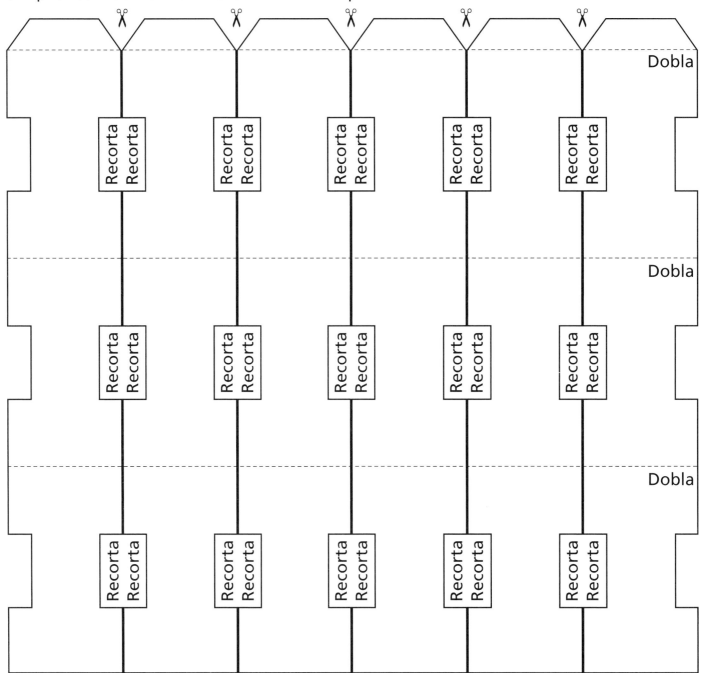

¿Qué otros módulos puedes hacer para crear una escultura?

Sé crear una escultura modular.

Nombre _____ Fecha _____

La historia cobra vida

Escribe los nombres de dos artistas de diferentes épocas. (Miguelángel y Picasso, por ejemplo.) ¿Qué dirían ellos que tiene de especial su arte? Escribe una conversación entre ellos. Dibuja la escena donde conversan.

Una conversación entre _____ **y** _____

Sé pensar en la historia del arte.

Nombre _____ Fecha _____

Restaurar una colcha vieja

Aquí ves el fragmento de la esquina de una colcha de cuadros variados. Usa tu imaginación para restaurarla.

¿Qué tipos de líneas, formas, diseños, patrones y detalles podría haber tenido la colcha? Colorea tu diseño con crayones, marcadores o lápices de colores para hacer que la colcha se vea tan alegre como cuando era nueva.

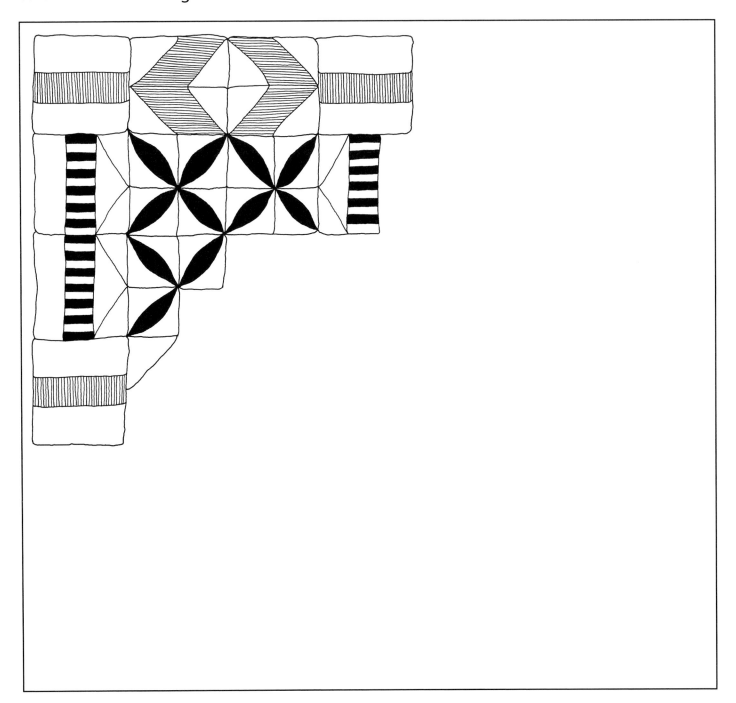

Entiendo algunas ideas sobre la restauración.

Nombre _____ Fecha _____

Estilos de sillas

Recorta cada tarjeta. Luego corta por las líneas de puntos. Tendrás entonces 12 partes de sillas. Combina diferentes partes de arriba y de abajo de las sillas. ¿Qué sillas se ven raras cuando las partes no hacen juego? ¿Por qué se diseñan las sillas de modo que la parte de arriba y de abajo sean del mismo estilo?

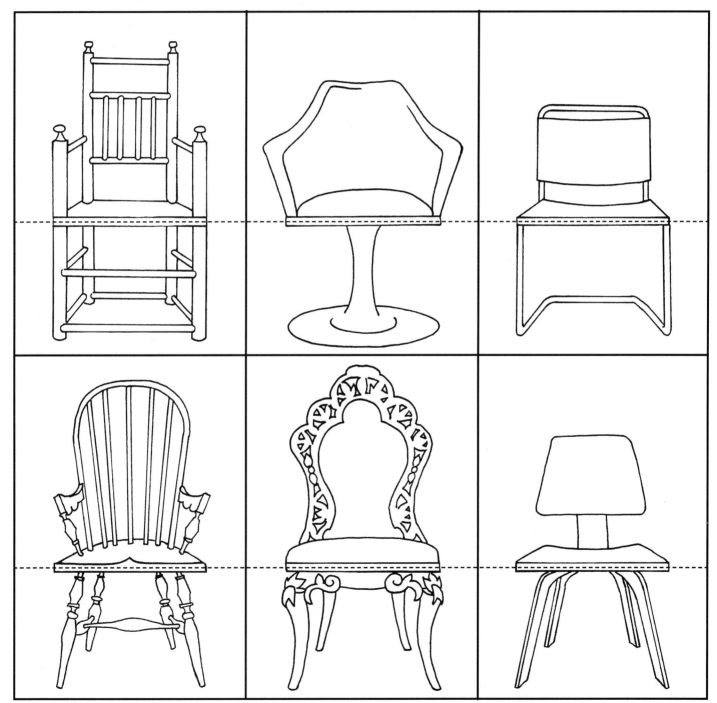

Conozco diferentes estilos.

Nombre _____ Fecha _____

Arte que te gusta

Marca una X junto al tipo de arte que más te gusta. Pídeles a algunos amigos o familiares que marquen una X junto al tipo de arte que más les gusta a ellos.

	Paisajes	
	Vistas marinas	
	Retratos	
	Naturalezas muertas	
	Obras abstractas	

Cuenta las X de cada recuadro.

¿A cuántas personas les gustan los paisajes? _____

¿A cuántas personas les gustan las vistas marinas? _____

¿A cuántas personas les gustan los retratos? _____

¿A cuántas personas les gustan las naturalezas muertas? _____

¿A cuántas personas les gustan las obras abstractas? _____

A más personas les gustan _____ que _____.

A menos personas les gustan _____ que _____.

¿Por qué crees que a la gente le gustan algunos tipos de arte más que otros?

Sé que la gente prefiere algunos tipos de arte a otros.

Nombre _____ Fecha _____

Un día sin arte

Los artistas diseñan muchas cosas que ves y usas. ¡Imagina empezar el día sin arte!
La caja de cereal no tiene ningún diseño.
El tazón del cereal no tiene ni color ni patrón.
La cuchara necesita forma.
¡Puedes arreglarlo todo!
Añade diseño, color y
forma para empezar
tu día con arte.

Sé algo sobre el arte de la vida cotidiana.

Nombre _____ Fecha _____

Analizar una obra de arte

Tu maestro te va a mostrar una obra de arte. Obsérvala detenidamente. Marca el cuadrito de cada fila que describe mejor lo que ves. Por ejemplo, si la obra tiene muchos colores vivos, marca el cuadrito que queda más a la izquierda. Si tiene colores vivos y colores apagados, marca el cuadrito del medio. En las filas vacías, añade otras cosas que notes.

muchos colores vivos	☐	☐	☐	☐	☐	muchos colores apagados
muchos colores oscuros	☐	☐	☐	☐	☐	muchos colores claros
muchos colores fríos	☐	☐	☐	☐	☐	muchos colores cálidos
texturas lisas	☐	☐	☐	☐	☐	texturas rugosas
formas con contornos definidos	☐	☐	☐	☐	☐	formas con contornos difuminados
formas realistas	☐	☐	☐	☐	☐	formas planas o inventadas
apariencia de profundidad con vistas distantes	☐	☐	☐	☐	☐	poca profundidad o primer plano
áreas con muchos detalles	☐	☐	☐	☐	☐	áreas con pocos detalles
áreas con equilibrio simétrico	☐	☐	☐	☐	☐	áreas con equilibrio asimétrico
	☐	☐	☐	☐	☐	
	☐	☐	☐	☐	☐	
	☐	☐	☐	☐	☐	

Comenta tus resultados con tus compañeros. Razonen sus diferencias.

Sé analizar el arte.

Nombre _____　Fecha _____

Reportaje sobre el arte

Imagina que trabajas en un periódico. Debes escribir sobre una obra de arte que escojas. Completa el resumen con notas sobre la obra.

Nombre del artista _____

Título de la obra _____

Lugar donde se exhibe _____

Materiales usados en la obra _____

Cómo el artista usó los materiales _____

Lo que muestra la obra _____

Cosas especiales que notar _____

Por qué la gente querría ver la obra _____

Otras ideas: _____

Usa tus notas para escribir un artículo que hable sobre la obra.
Usa una hoja de papel aparte.

Sé planear y escribir un reportaje sobre el arte.

Nombre _____ Fecha _____

Autobiografía

Escoge una obra de arte de tu libro. Imagina que la obra puede hablar. ¿Qué relato contaría sobre su vida? Completa el resumen con notas sobre la obra.

Mi nombre es (título de la obra) _____

Cómo me crearon _____

Lugares donde he estado _____

Lo que han admirado sobre mí _____

Lo que me gustaría que la gente notara sobre mí ahora _____

Sucesos importantes durante los cuales he vivido _____

Otras cosas en las que pienso _____

Usa tus notas para escribir una autobiografía imaginaria de la obra.
Usa una hoja de papel aparte.

Sé cómo planear y escribir sobre el arte.

Nombre _____ Fecha _____

De paseo

Tu maestro te va a mostrar una pintura de un paisaje. Un paisaje es una escena al aire libre. Imagina que pudieras hacerte muy pequeñito y caminar por esta escena. Observa los alrededores. Camina por el paisaje. Escribe lo que ves y cómo lo muestra el artista.

Lo que veo	**Cómo el artista lo muestra**
El tiempo está _____ _____.	_____ _____
La hora es _____ _____.	_____ _____
La estación es _____ _____.	_____ _____
El viento es _____ _____.	_____ _____
El lugar más frío es _____ _____.	_____ _____
El lugar más cálido es _____ _____.	_____ _____
La cosa más interesante es _____ _____.	_____ _____

Conozco diferentes maneras de observar el arte.

Nombre _____ Fecha _____

Puedes ser crítico de arte

Un crítico de arte escribe y habla sobre las obras de arte. Un crítico de arte ayuda a las personas a pensar en el arte.

Recorta las cuatro tiras. Dobla cada tira por la mitad para hacer una tarjeta de crítica de arte. Usa las tarjetas para hablar y escribir sobre el arte. ¡Sé crítico de arte!

1. Observa	2. Observa de nuevo	3. Piensa	4. Opina
Observa la obra detenidamente. ¿Qué quiere el artista que veas? _____ _____ _____ _____ _____	Busca el diseño general de la obra. _____ _____ El diseño general te ayuda a entender cómo se planeó la obra.	Piensa en lo que ves y sientes. ¿En qué quiere el artista que pienses o cómo quiere que te sientas? _____ _____ _____	Decide lo que te gusta o no te gusta de la obra. _____ _____ Indica por qué te gusta o no te gusta la obra. _____ _____

----DOBLA POR AQUÍ---- · ----DOBLA POR AQUÍ---- · ----DOBLA POR AQUÍ---- · ----DOBLA POR AQUÍ----

Cosas que ver	Planes que notar	Ejemplos	Preguntas
• temas • materiales • líneas • colores • figuras • texturas • formas • espacios (Tu maestro te puede ayudar a entender estos términos.)	• patrones • equilibrio • movimientos • ritmos • énfasis • unidad • variedad (Tu maestro te puede ayudar a entender estos términos.)	Emociones: • rareza • alegría • miedo • tristeza Ideas: • sabiduría • belleza • valentía • amor	¿Por qué crees que el artista creó esto? ¿Qué podrían pensar otras personas de esta obra? ¿Por qué? ¿Qué te gusta y no te gusta de la obra?

Sé opinar sobre el arte.

Nombre _____ Fecha _____

Refranes sobre el arte

Lee cada declaración sobre el arte y piensa en ella.
Junto a cada oración, escribe lo que crees que significa.

Hay imágenes en
los poemas y poemas
en las imágenes.

El arte no tiene
enemigos sino la
ignorancia.

Hay algo de arte hasta
en el asar manzanas.

Aquellos que tienen
un arte tienen en
todos sitios una parte.

Sé explicar declaraciones sobre el arte.

Informe para los padres

_____ está progresando en estas áreas del arte.
(estudiante)

Expresión creativa

_____ Usa los conceptos de diseño para propósitos particulares, como el color para expresar un estado de ánimo y la repetición para crear ritmos visuales.

_____ Usa los medios para aumentar sus destrezas y su adaptabilidad al crear arte expresivo de dos y de tres dimensiones.

_____ Presta atención a las intenciones expresivas.

Percepción

_____ Identifica cualidades visuales sutiles en el entorno natural y el fabricado y en las obras de arte.

_____ Nota los estados de ánimo, las trayectorias de movimiento sugeridas y las interacciones entre los colores y las figuras.

Cultura y herencia

_____ Compara y distingue entre las funciones culturales e históricas de las obras de arte.

_____ Reconoce las tradiciones artísticas en la vida cotidiana.

_____ Respeta la creación y el estudio del arte como una exploración de por vida o una profesión.

Formar opiniones

_____ Busca respuestas a las preguntas sobre las cualidades de las obras de arte.

_____ Basa sus opiniones sobre las obras de arte en sus conocimientos y reflexiones.

Otros comentarios: